D1288615

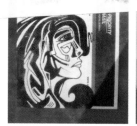
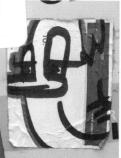
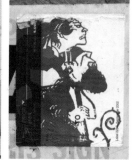
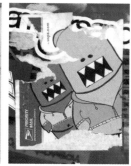

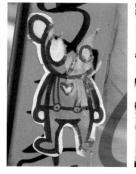
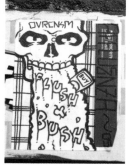

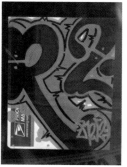
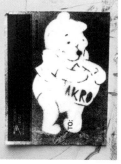
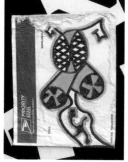
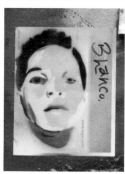

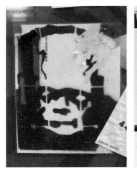
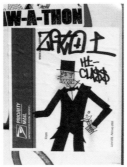
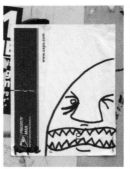
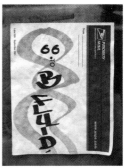
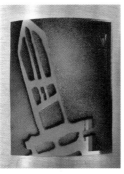
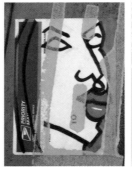
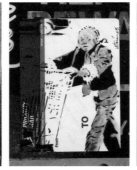

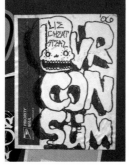
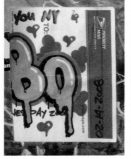
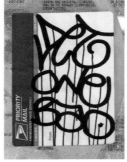

GOING POSTAL

Martha Cooper

Mark Batty Publisher | New York City

STUCK ON STICKERS

By Martha Cooper

I'm a veteran of street-art photography having documented graffiti since the late 1970s. In the early 80s I began to see tags on stickers but didn't pay much attention. In 2002 I bought my first digital camera. Its small size made it ideal to carry around and that's when I began to photograph stickers intensively. Hand-drawn and stenciled stickers especially caught my eye. I enjoyed seeing examples of both classic tags with graffiti-style lettering and street art with characters or other images. These two distinct disciplines have intersected on postal stickers. Although many artists now print their stickers commercially, I most appreciate the few who take the time to create theirs by hand. Good ones are hard to find and as GET2 (28-29) says, "Seeing a hand drawn sticker is an experience."

When graffiti writers began using stickers to tag on in the early 80s, there were obvious advantages. Stickers could be prepared en masse in advance in a controlled environment and slapped up quickly with a lot less risk than bombing with spray cans or markers. At first, kids tagged their names on stickers in the same graffiti style they used on the street. The "Hello My Name Is" stickers, manufactured for conventions, were especially apt for a tagged name, but they were small whereas the USPS Priority Mail Label 228 had a large amount of white space, excellent adhesion and best of all was free and readily available at local post offices. It could also be ordered directly from the Postal Service in large quantities. Label 228 quickly became the street sticker of choice. As COSBE (32-33) says, "You gotta take what you can get, to do what you want to do." The 1998 Priority sticker had more white space than any of the previous designs and some older sticker artists still have a supply of these. GET2 uses his

sparingly in 2008 to indicate that, "I know my roots. I have old skool stickers."

Artists modify postal stickers to suit their fancy. FAUST (3, 40-41) flips the sticker upside down and cuts off the blue Priority Mail band, feeling that it's too bold and detracts from his name: "It has too much weight and is not important to the message I am trying to communicate." C.DAMAGE (24-25) cuts out her signature teddy bear character "The Dude" and saves the hundreds of leftover blue strips with the idea of eventually making a large piece with them. COSBE pre-weathers his stickers by tearing them into 3-5 pieces, feeling that they might last longer if they already look partially scraped. He gets rid of the USPS logo—"I feel like it's not mine so why should I support them?"—but he leaves the red line. GET2 also shapes his stickers and sometimes incorporates the red stripe into his drawings. He always keeps part of the original to show the government that, "I am repurposing your material." On the other hand, STAIN (38-39) will sometimes "paint over the whole thing to give myself a clean slate." Unlike spray-can graffiti, a postal sticker has a defined border. The challenge is to fill the frame in an original and eye-catching way.

Although all the sticker artists I have spoken with are more concerned with quality than quantity, anyone who is serious about stickers needs to make impressive numbers quickly and repeatedly. Consistency is important. GET2's stickers have "recurring themes designed to be instantly recognizable." STAIN might take hours cutting a stencil but says it only takes minutes "to bang out a good amount." COSBE claims he doodles his best stickers while talking on the phone. He averages 30-60 per day—every day. C.DAMAGE usually does runs of similar designs and sometimes,

because her bears are so kid friendly, lets children help with the fill-ins. FAUST tags his name quickly and expertly on hundreds of stickers in a breathtaking range of styles with a recognizably consistent "crispy" edged Pilot chisel tip Sharpie marker.

Placing stickers is as important as making them. Stickers adhere best on smooth surfaces such as plastic, metal and marble. FAUST prefers using newspaper boxes as showcases because the sticker is behind clear plastic and sheltered from the weather. It's rare to see a box in NYC without one of his stickers. Sometimes he will go through his stack and choose his best stickers to place in the most highly trafficked, hippest areas of the city where people will be sure to notice them. GET2 wants to place his stickers where they won't be destroyed but still have high visibility. Sometimes he'll walk for 20 or 30 blocks before finding a spot, even if visibility is so high that the spot is prone to buffing. "I'm placing stickers," he says, "not bombing stickers. If the spot screams at you, you have to take it!"

C. DAMAGE wants her stickers to fit in with the surroundings and is always on the lookout for an interesting place to get up, "a place with really good scenery around that will add something to my sticker or my sticker will add something to the environment." She feels that her bear-shaped "Dude" stickers are "little soldiers sent off to war." When one is buffed or beheaded or crossed out, it's as if "he took one for the team." For OVER-CONSUME (66-67), high visibility is first and foremost but longevity is a consideration: "You want as many people to see your handiwork as possible. Long lasting is good too, reminds yourself where you've been. I do a lot of inaccessible places because these places are the longest lasting. People

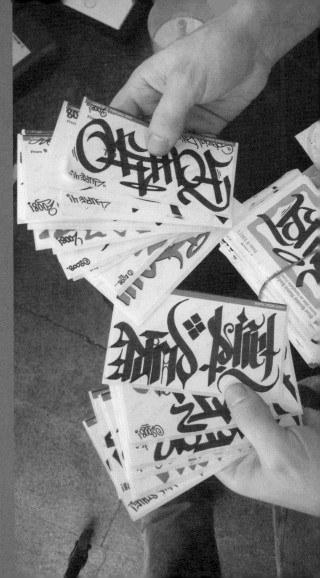

ask me why because no one will see it. It doesn't matter really, you leave your mark and if at least one person sees it, then you did your work."

Stickers are everywhere in New York City, but only people attuned to their existence notice them. The audience for graffiti and street art in general is a small percentage of the population. FAUST would like as wide an audience as possible. He would like everyone from young kids to old-school writers he admires to see his work, but ultimately he claims he doesn't really care who notices. STAIN hopes to "share the work with the general public and other artists passing by. To possibly inspire as I have been inspired by the work on the street."

OVERCONSUME, who draws some of the most overtly political stickers says, "I want my audience to be everyone. My expectation when I put up stickers is to make sure people know my name and can clearly understand it, no inside/hidden messages, but some jokes slip in too. My messages are sometimes political, and a lot of times venting. I'm an emphatic person. I like to use the skull as one of my icons because it's bold and represents death. My character throwing up letters "FLUSH BUSH" speaks for itself. When I write it out, I like to use funky demon letters because they lend themselves to horror. Over-consumption is what a lot of people do mindlessly, be it throwing away a shitload of trash and not recycling or just buying material possessions that aren't needed. On the whole though, I think most people who come across my stickers understand them fairly easily."

Although slapping a sticker carries a lot less risk than tagging, most sticker artists are discreet about their activities. When FAUST started, his golden rule was never to carry markers when putting up stickers and vice versa in order to maintain "deniability" if caught. In New York there have been a few cases of sticker arrests and there are enough tales of run-ins with the law in other cities to warrant caution.

There is a substantial and growing internet community of sticker artists. Flickr has become the premier site for sharing photos of fresh art and exchanging stickers worldwide. In addition to trading stickers in the States, C.DAMAGE has traded with artists from Brazil, Spain, New Zealand, England and, most surprisingly, Singapore, a country known for its severe punishment for any kind of graffiti writing. Some recipients of sticker exchanges slap up the foreign stickers, photograph and post them online. Whereas graffiti artists used to try to go "all city," some sticker artists are now aiming for "all world." GET2 joins internet groups if he likes their work. He says, "In order to see the repercussions of a local outing, I might wait a couple of weeks and then search for recent additions to public photo-storage sites to see if anyone has posted a photo of one of my stickers." FAUST, however, eschews the internet and street artists in general. He prefers stickers with classic graffiti lettering styles found on the street.

Many sticker artists first started out by creating a tag and writing graffiti. COSBE, for example, really likes lettering and has practiced long and hard on his style. He says that when he first moved to New York from Chicago and put up his stickers beside local artists he thought, "Wow! I gotta step up my game! You gotta have good letters to do stuff here. You gotta have letters to do stuff in New York."

Different cities have different sticker scenes. In Philadelphia I was lucky to be guided around

by MALIC (44, 45) and MORG (45, 74, 76, 86), two prolific young sticker artists who have been friends since nursery school. Character tags predominate in Philly and stickering is a sociable activity. Artists get together for an afternoon or evening of drawing and often collaborate on a single sticker. In Philly I spotted wonderful examples of these collaborations on the street, many combining more than one 228 Label.

Some sticker artists such as COSBE are associated with various graffiti crews. Others work independently. GET2 gravitated away from graffiti, finding it a combative and violent culture in which it was difficult to make a mark. STAIN says, "I really do miss writing on things. There's an immediacy to the sticker—you can put it up in a second. But a tag is like poetry in motion—the friction of the application of the marker on the surface—it's a different sort of sensorial perception. Some people like the feel of materials in their hand—canvas, silk, baby skin. When you hit a tag, you're in touch with the surface. There's a rush of adrenaline with graff. I know there is beef between the two worlds but it's all art to me. It's all self-expression. Whose got time for bullshit?"

With slick commercial advertising occupying huge amounts of public space, it's refreshing to see anything made by hand. For me, looking for stickers is an on-going treasure hunt, increasing my pleasure as I walk around cities. Hopefully this book will both inspire more artists to take to the streets and ordinary people to open their eyes to what's in front of their nose.

Thanks to all the writers, taggers and sticker artists out there—rock on!

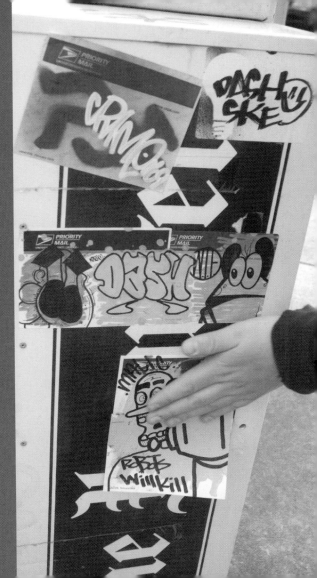

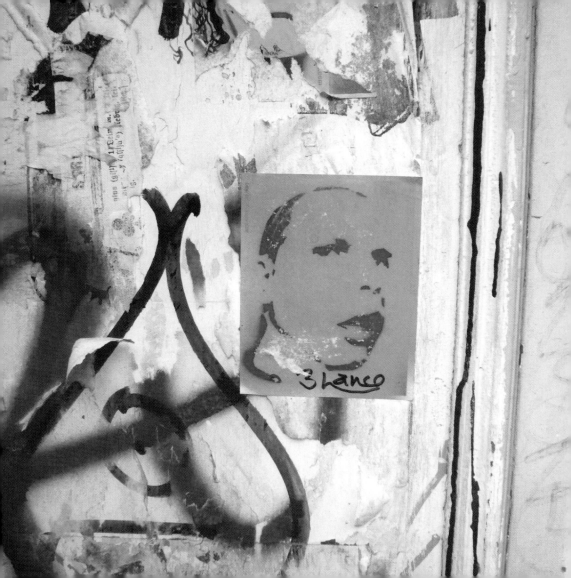

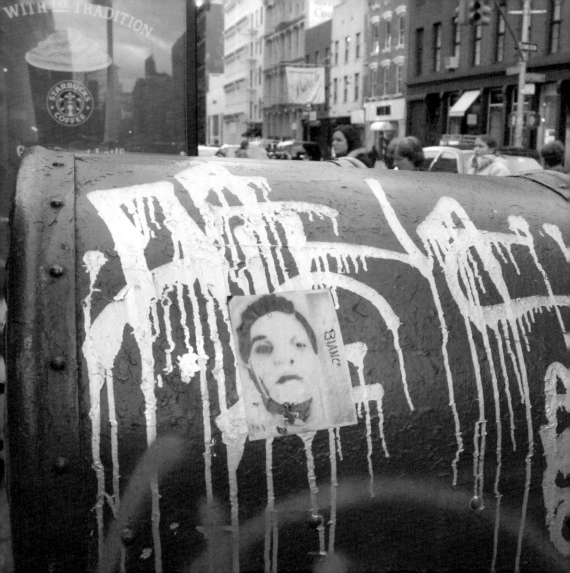

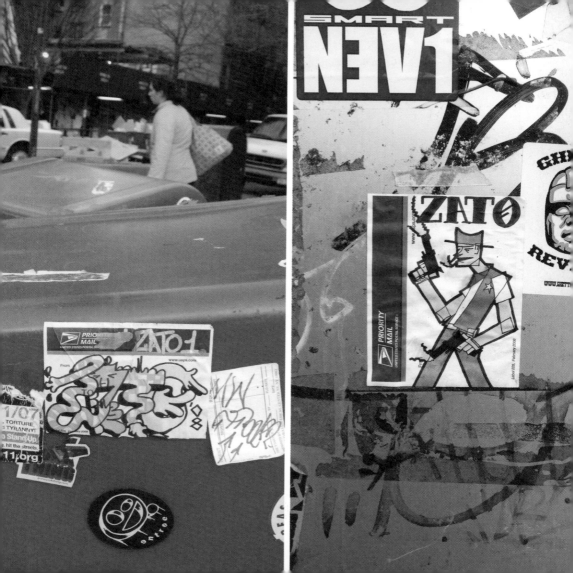

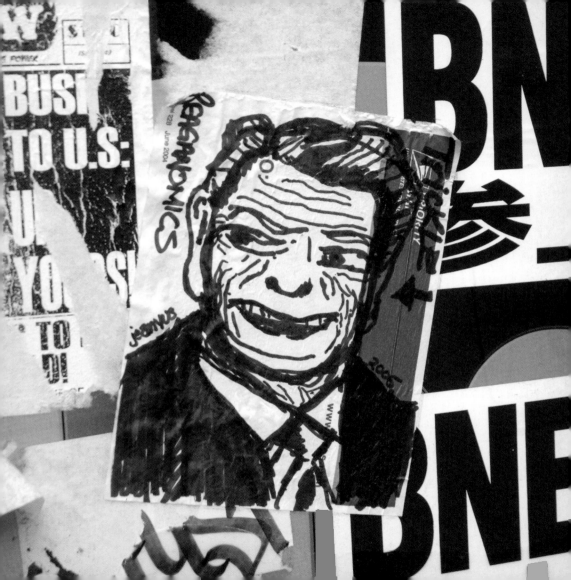

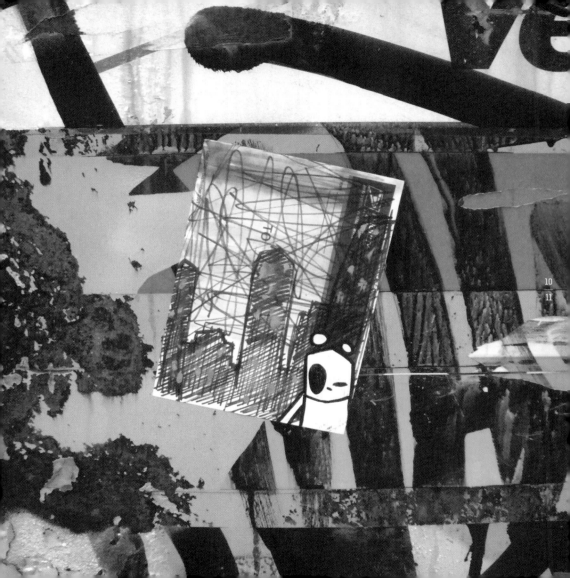

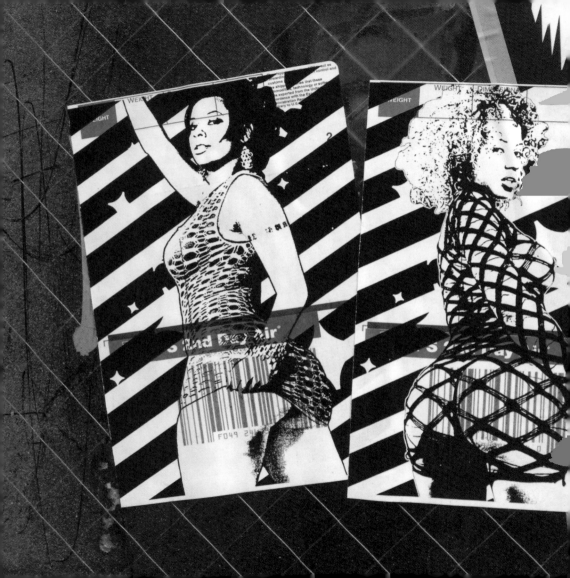

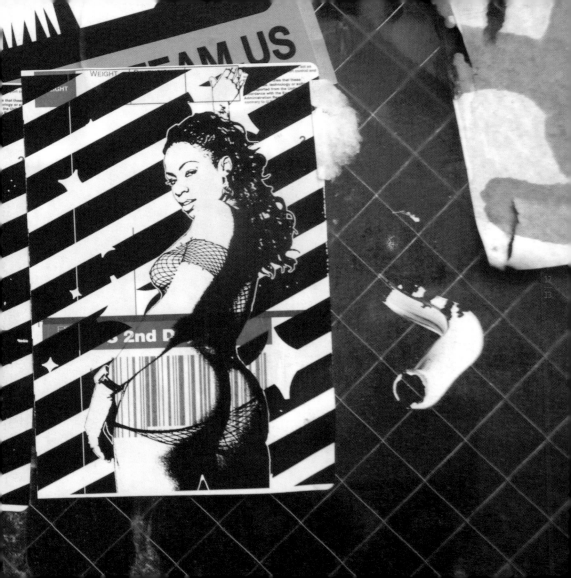

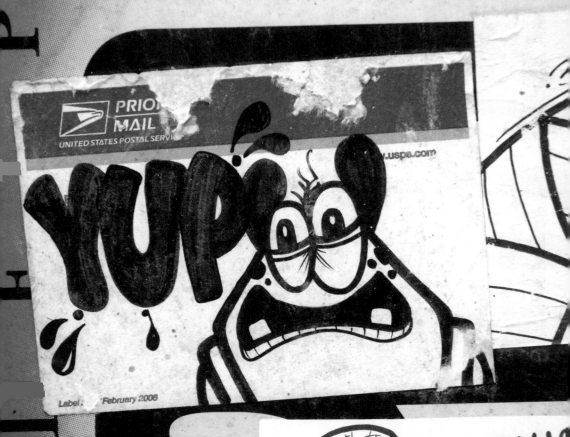

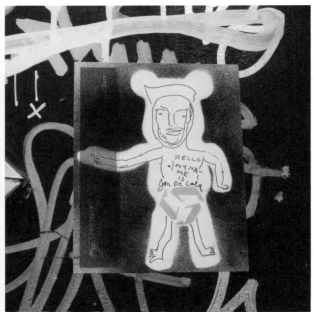

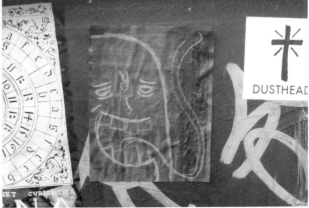

If this box is empty...

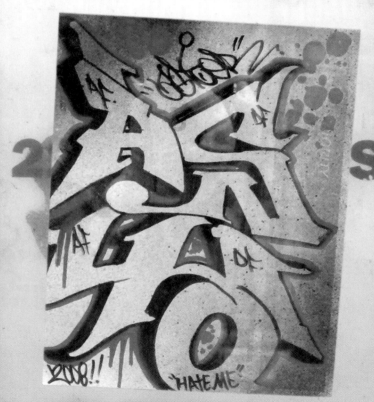

Catalogue

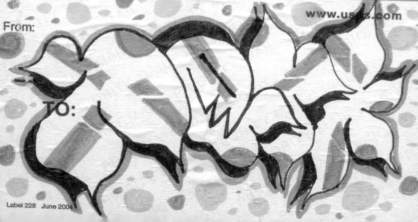

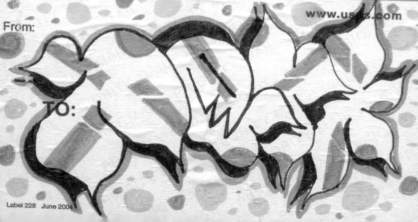

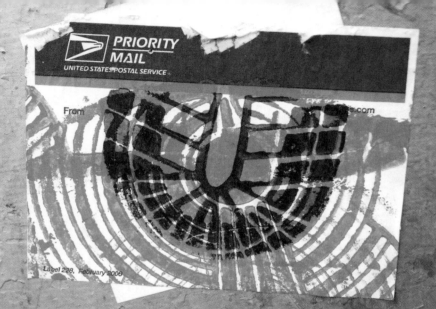

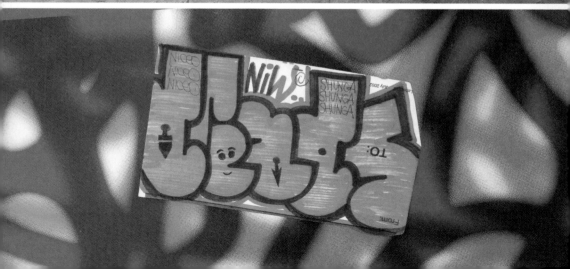

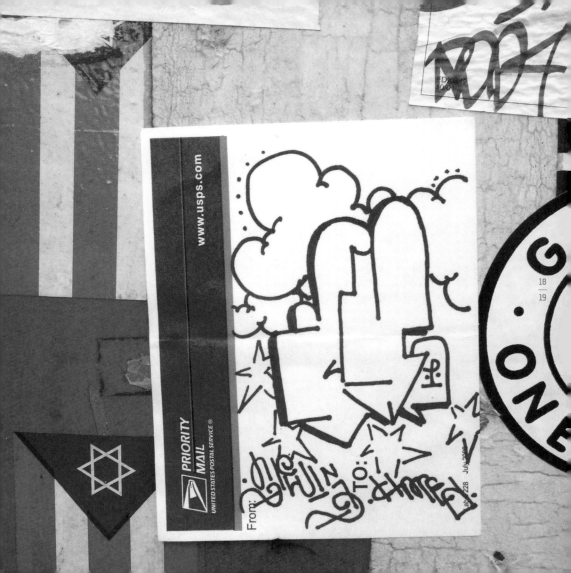

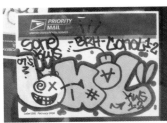 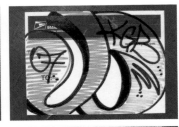 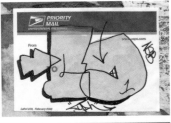

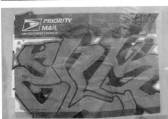 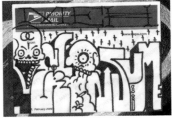 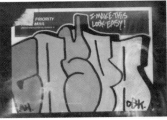

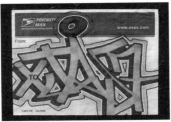 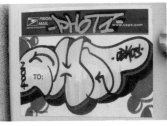 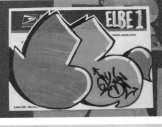

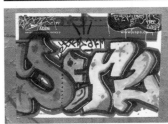 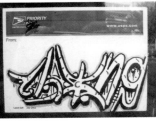 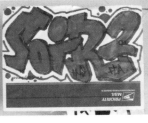

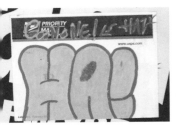 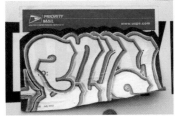 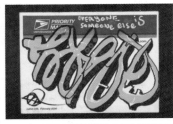

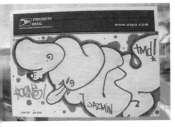 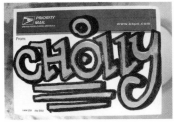 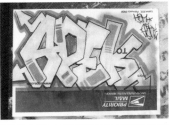

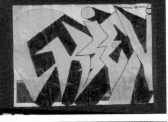 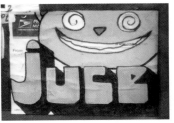 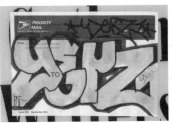

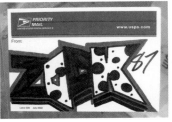 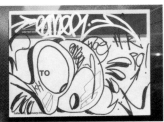 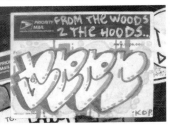

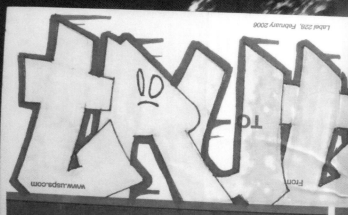

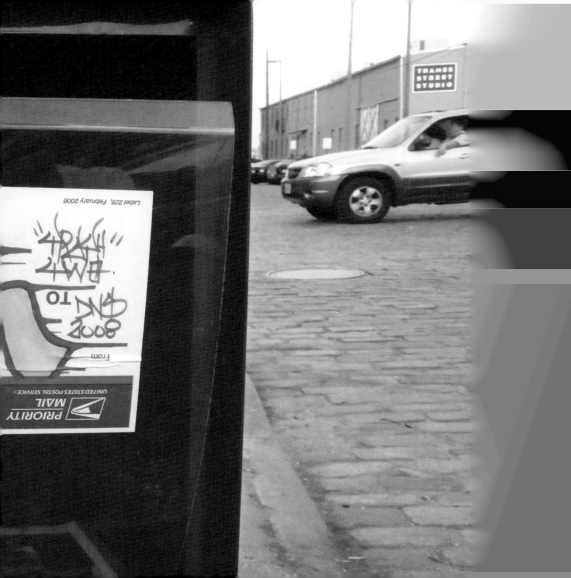

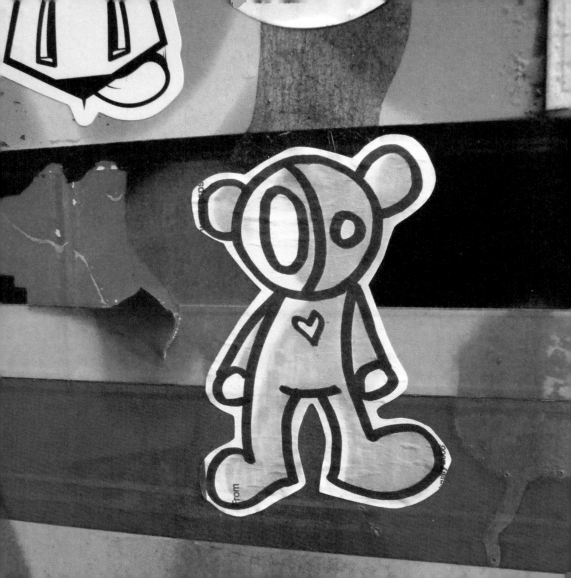

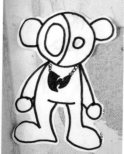
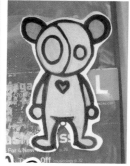
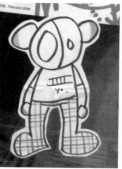
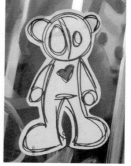
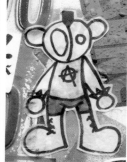
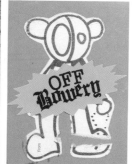

SHUT OFF VALVE
LOCATED 10 FEET
OPPOSITE THIS SIGN

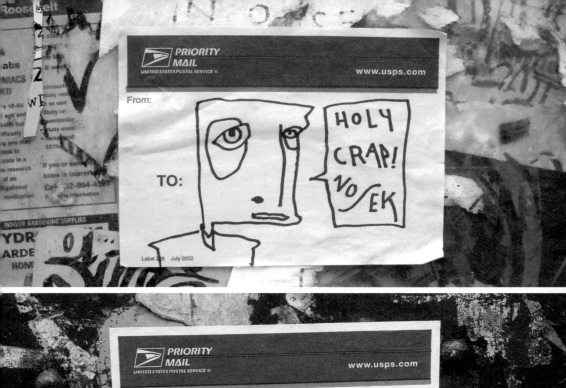
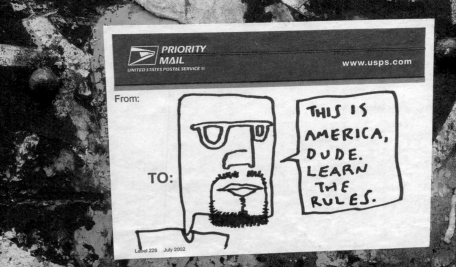

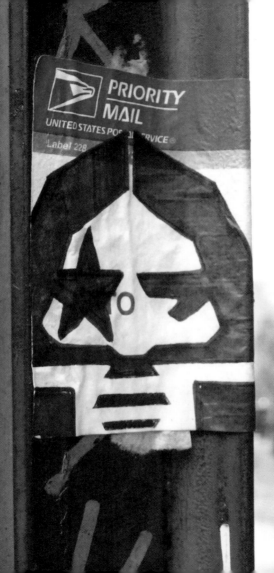

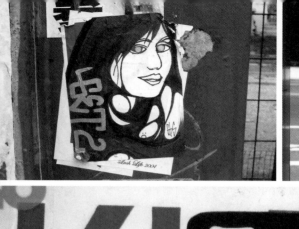

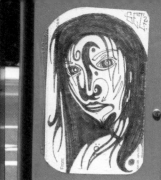

Plantas
que ayudan
a dormir mejor

MISS BRASIL 2007

Nat

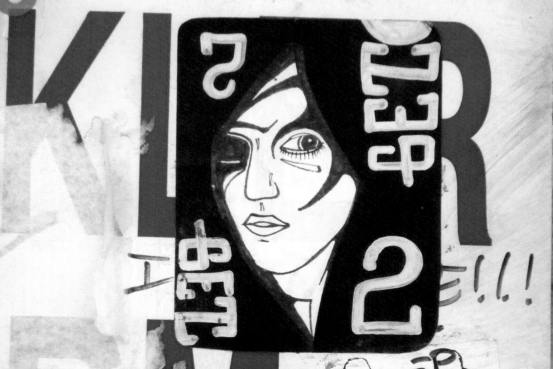

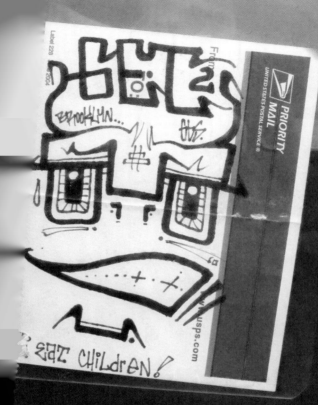

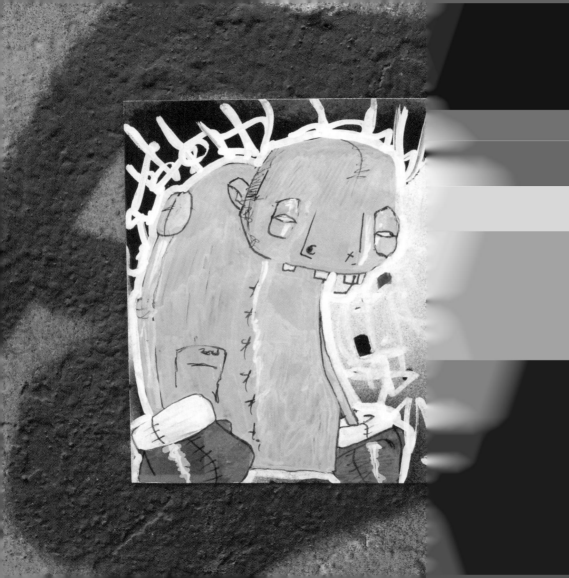

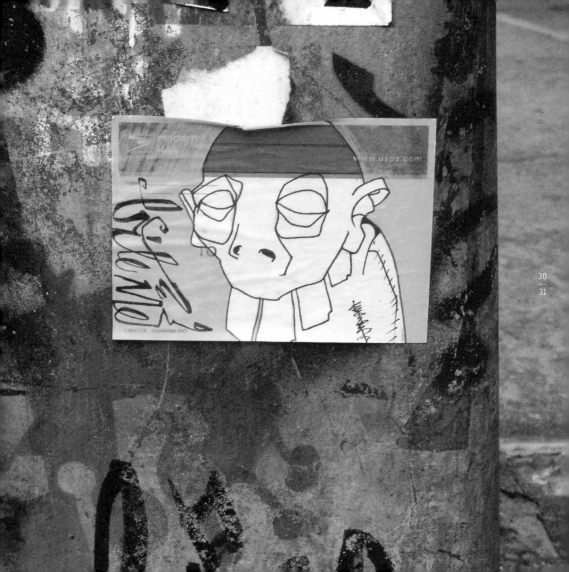

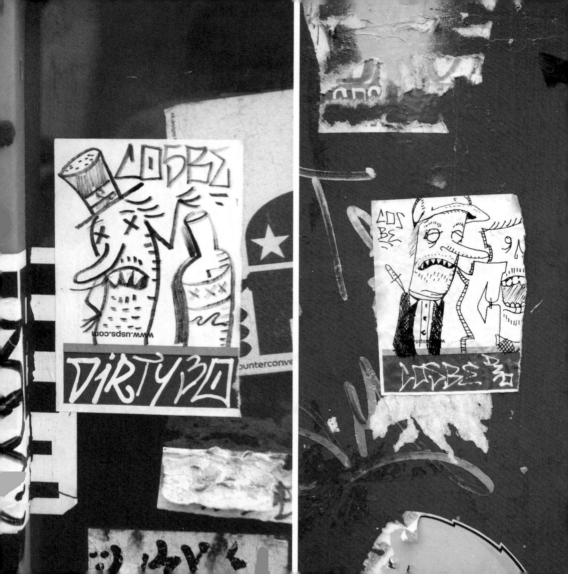

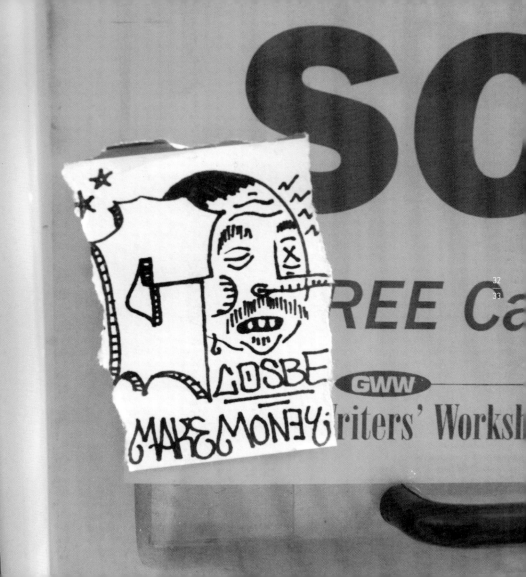

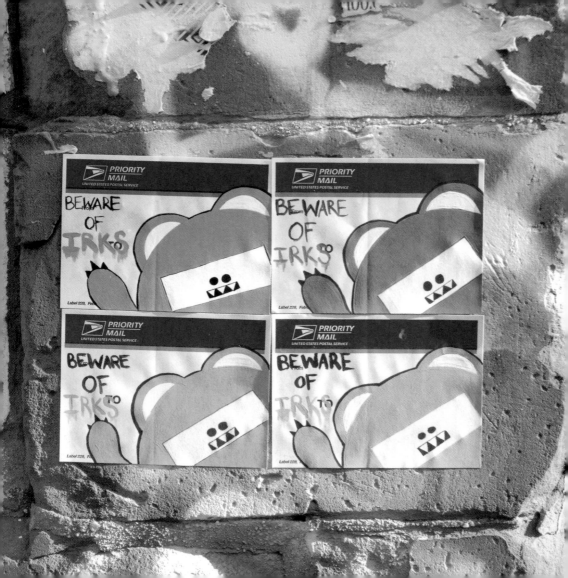

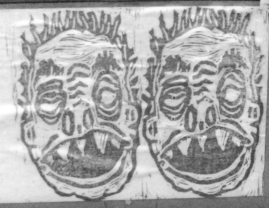

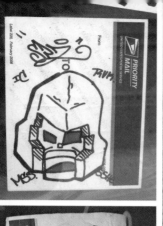

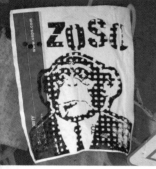

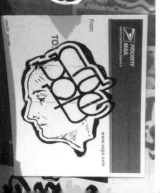

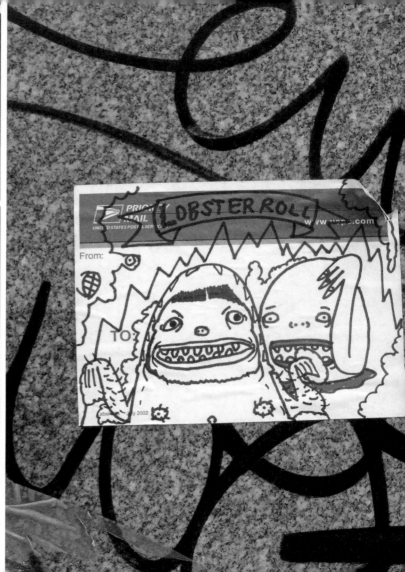

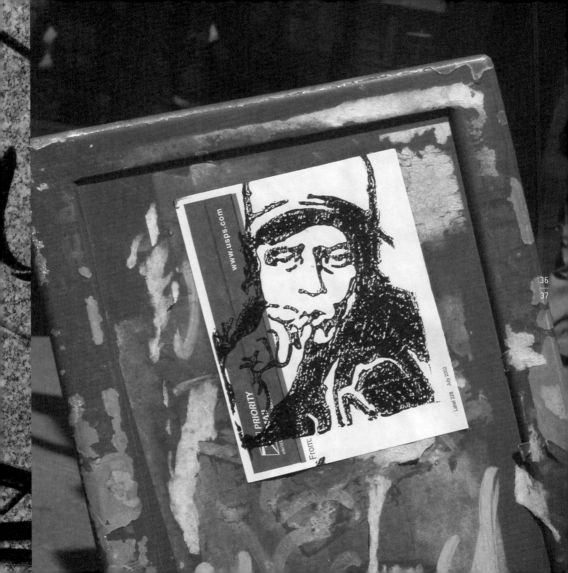

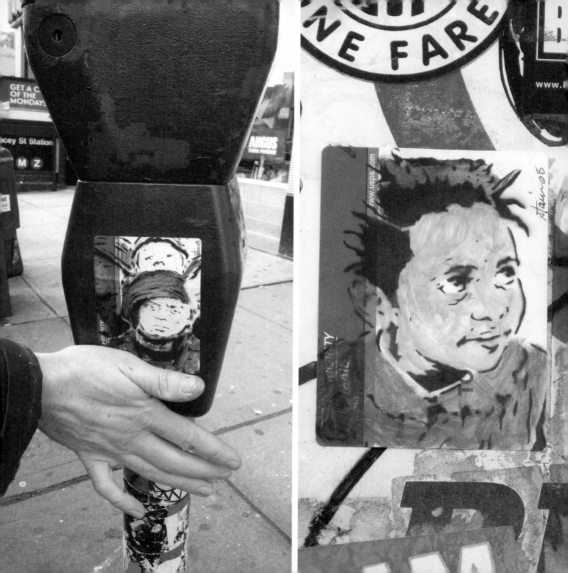

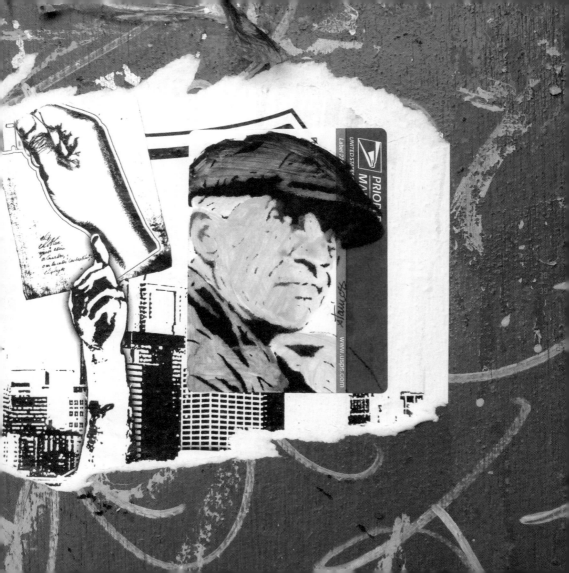

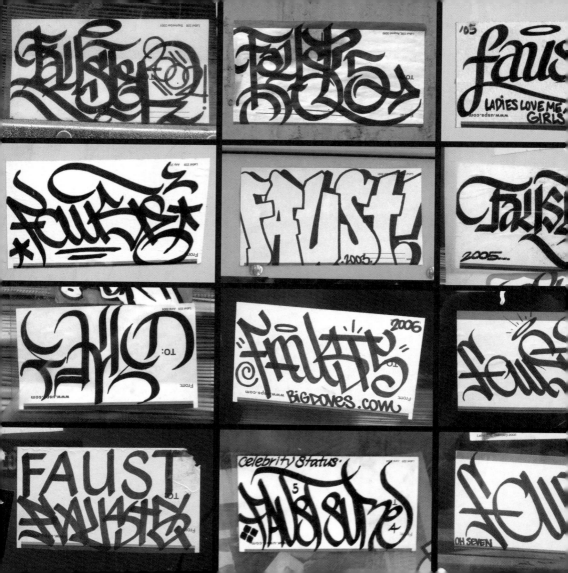

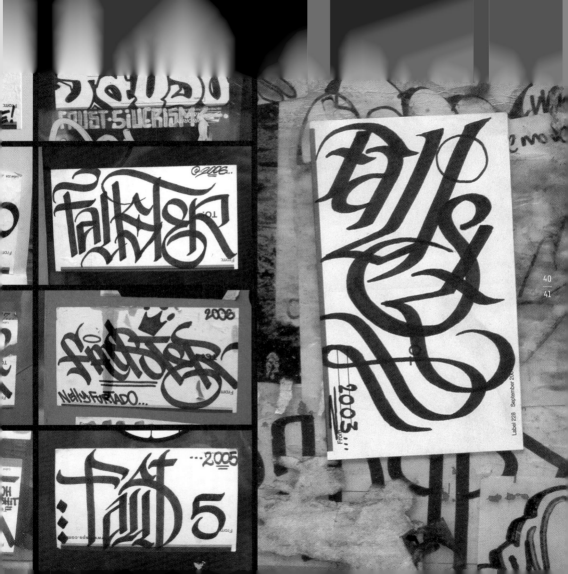

BLOOPA!08

also

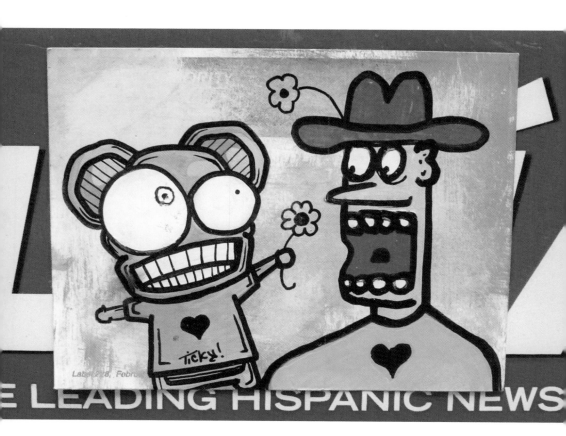

E LEADING HISPANIC NEWS

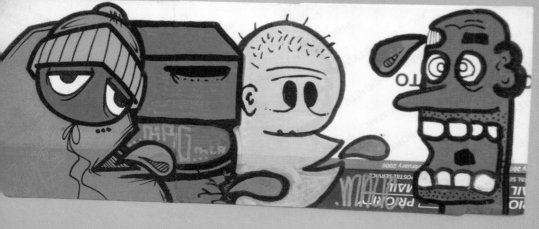

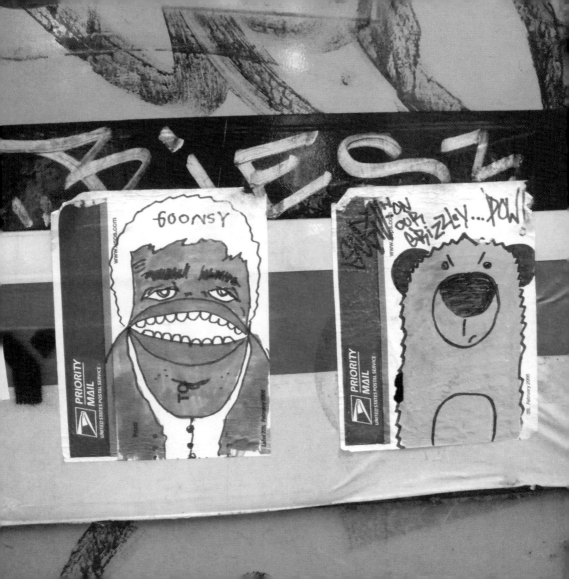

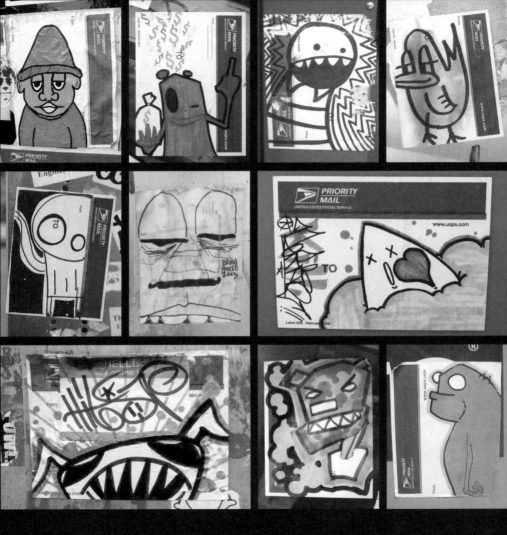

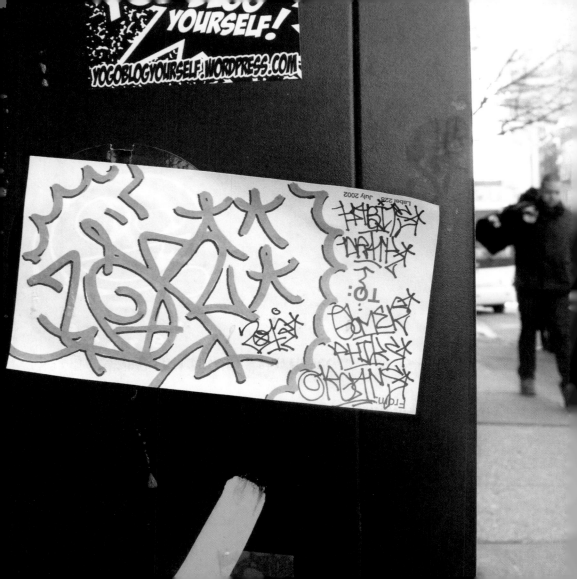

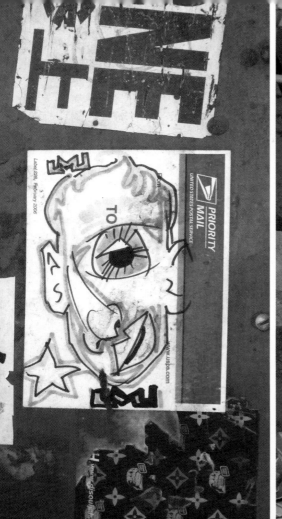

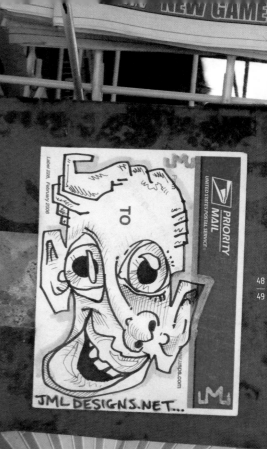

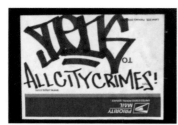
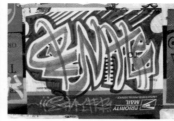
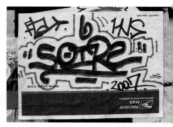

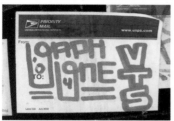
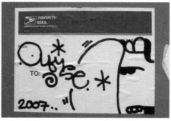
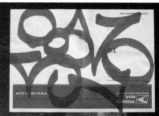

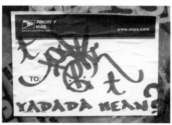
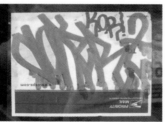
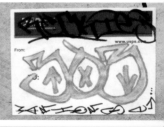

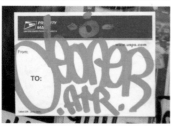
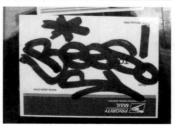
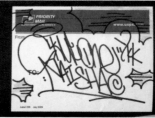

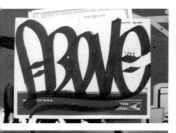
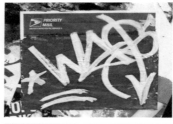
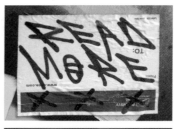

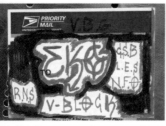
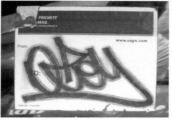
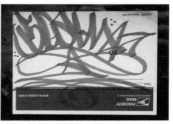

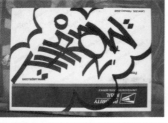
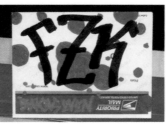
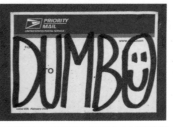

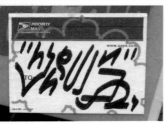
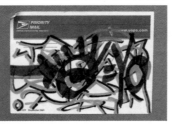
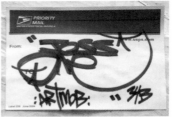

www.TheGreening.c...

Issue Date _____ Exp. Date _____

RiBiT

most
fun

PRIORITY MAIL
UNITED STATES POSTAL SERVICE ®
www.usps.com

From:

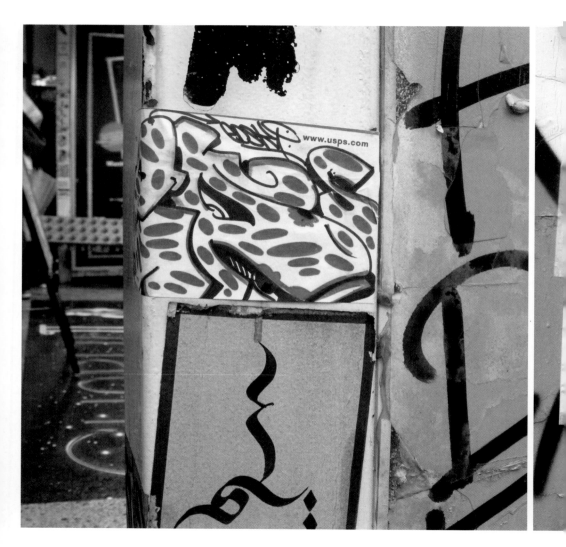

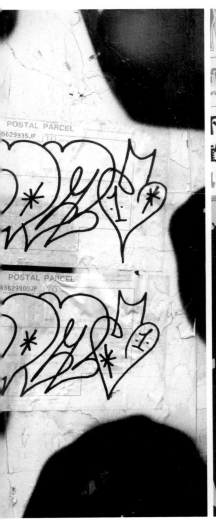

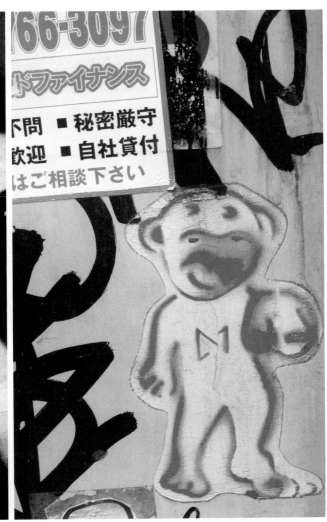

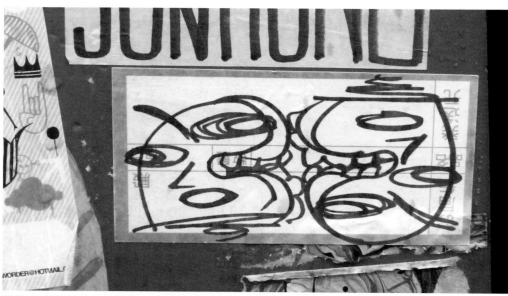

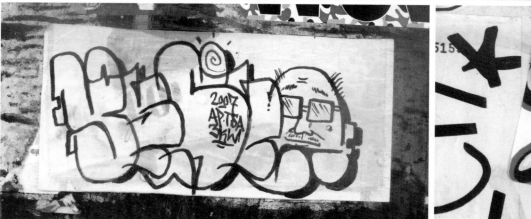

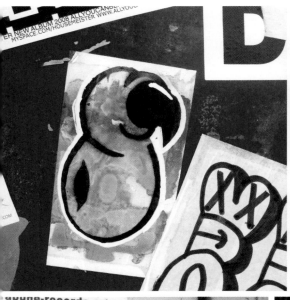

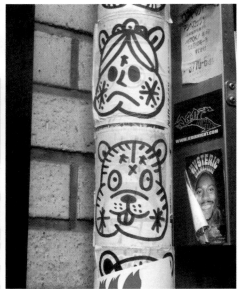

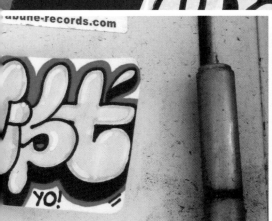

abune-records.com

YO!

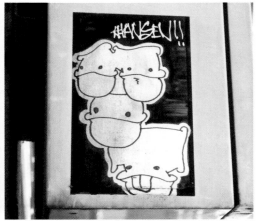

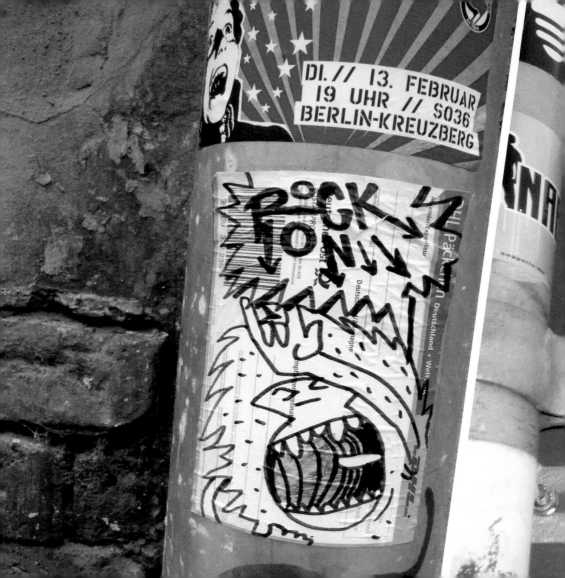

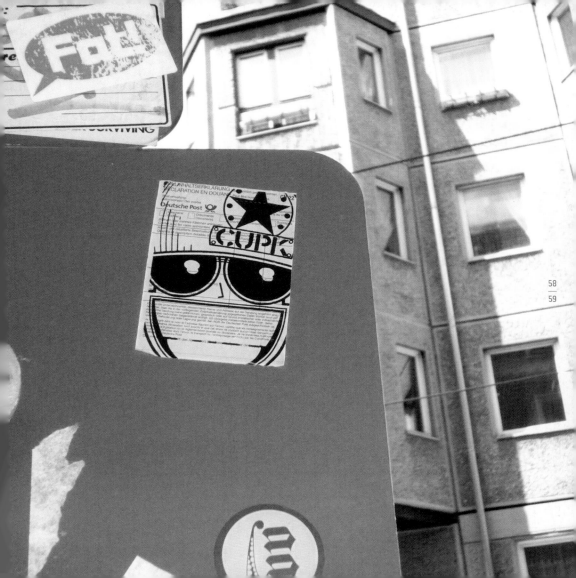

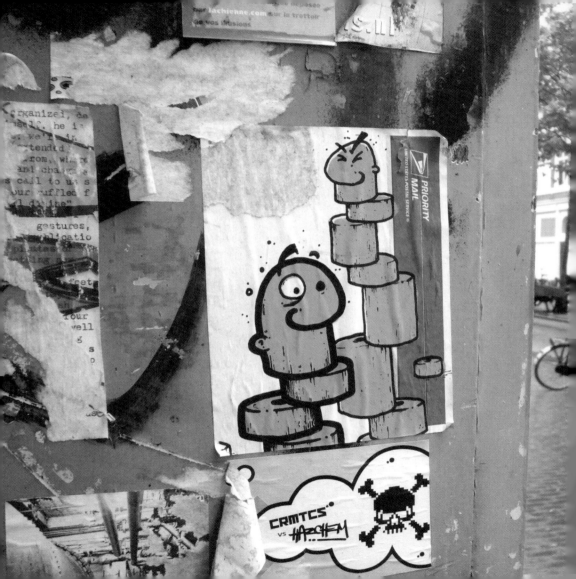

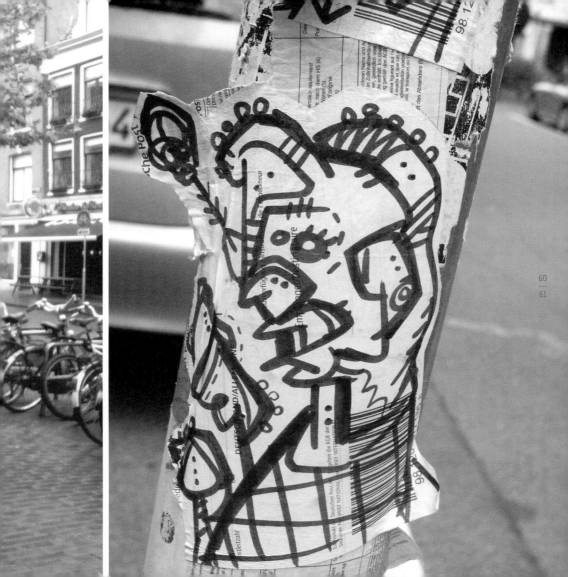

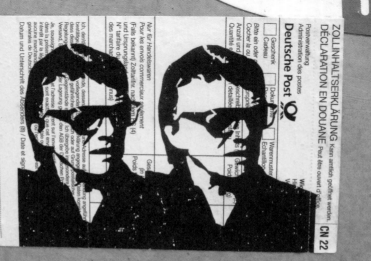

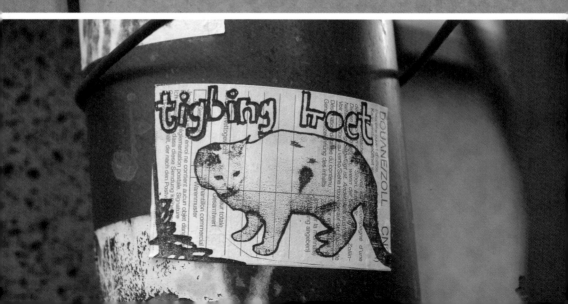

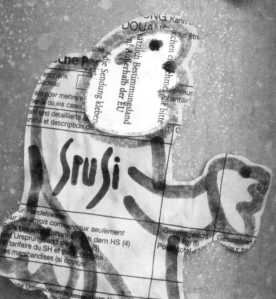

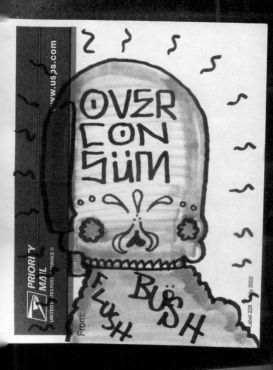

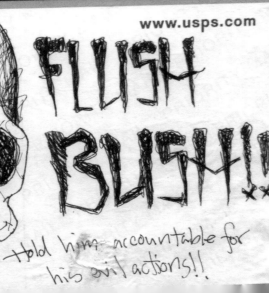

OVERCONSUME!!

PRIORITY
MAIL
UNITED STATES POSTAL SERVICE ®

www.usps.com

FLUSH
BUSH!!
xx

Hold him accountable for
his evil actions!!

Label 228 June 2004

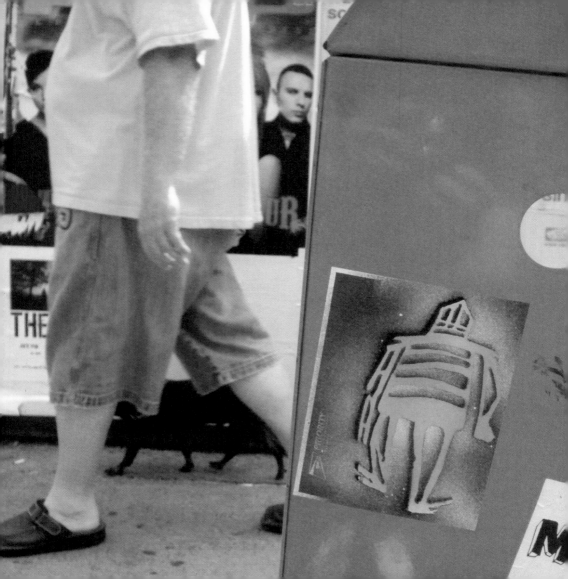

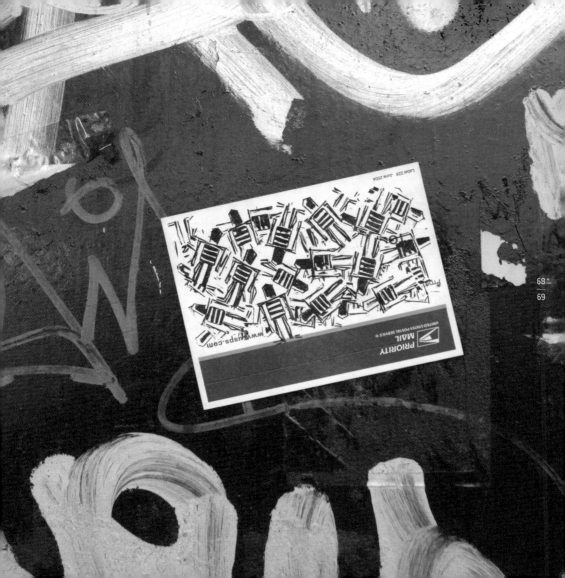

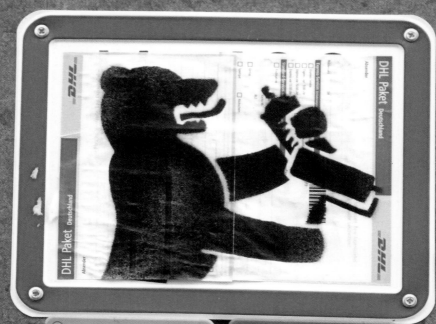

S Gas
2,2
1,6

AV Wasser
2,5
2,7

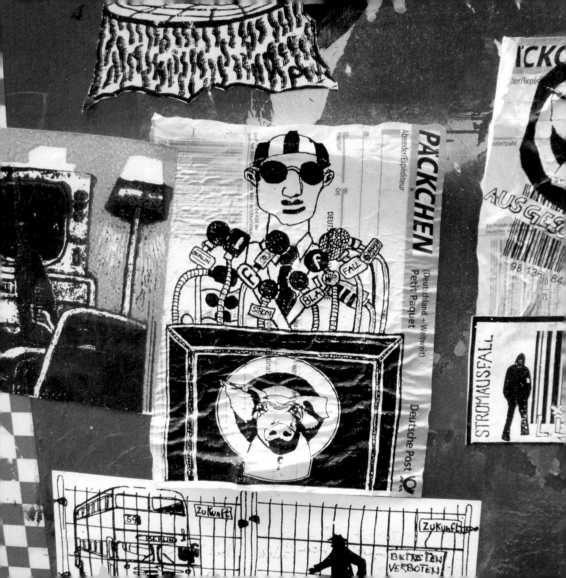

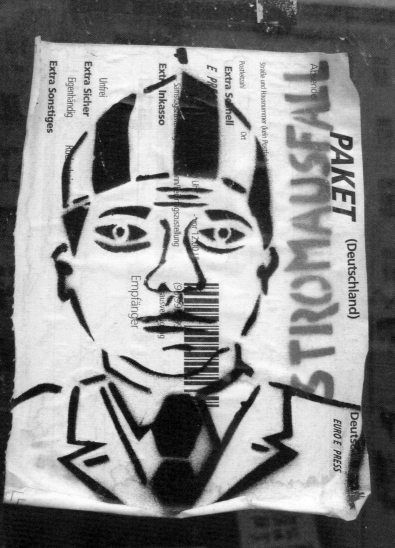

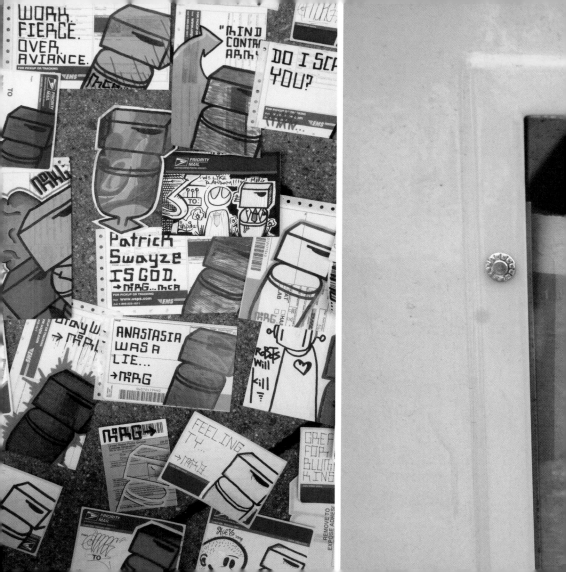

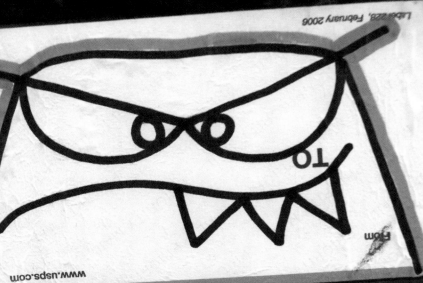

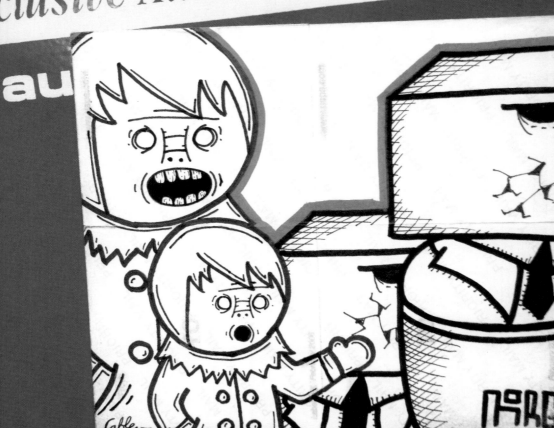

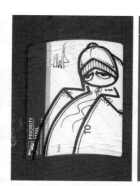

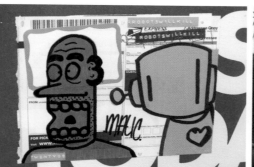

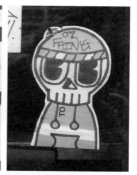

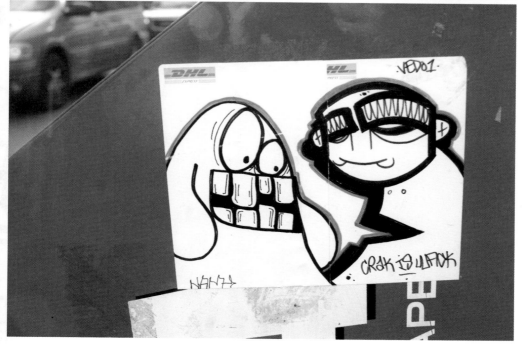

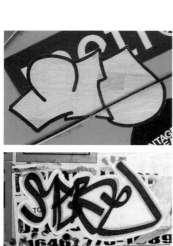
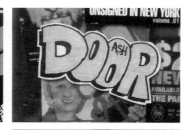
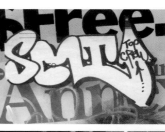
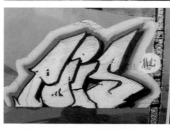
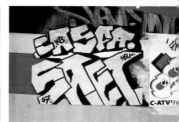
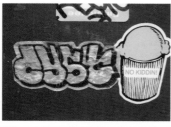
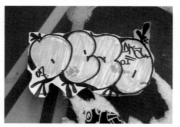
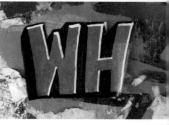
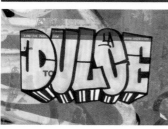
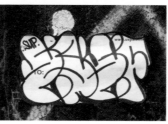
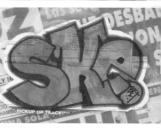

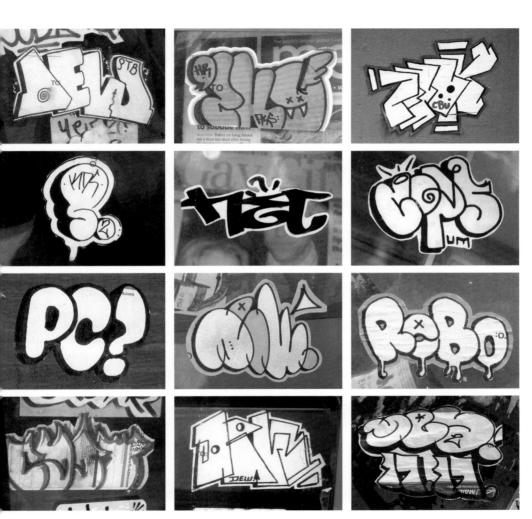

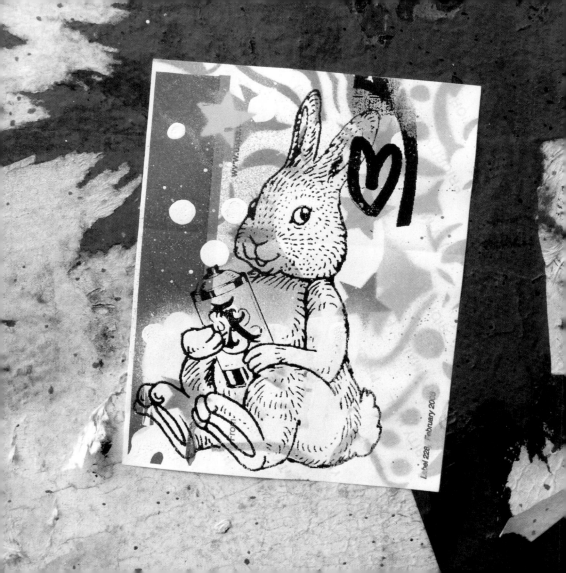

PRIORITY
MAIL
UNITED STATES POSTAL SERVICE®

www.usps.com

From

Label 228, February 2006

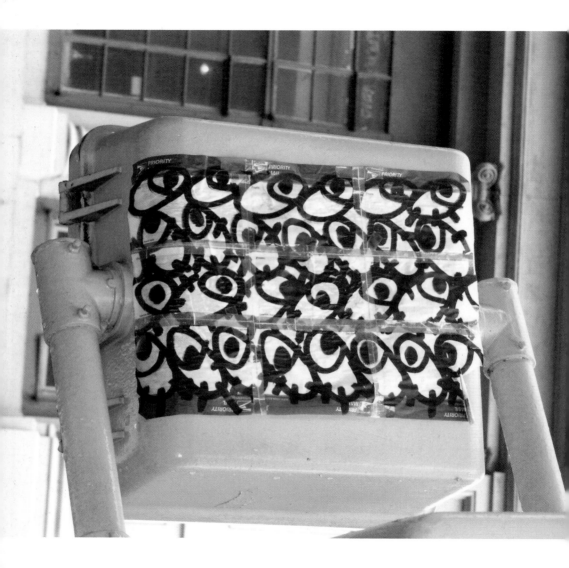

PRIORITY MAIL
UNITED STATES POSTAL SERVICE ®
www.usps.com

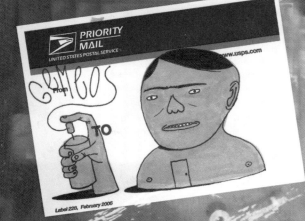

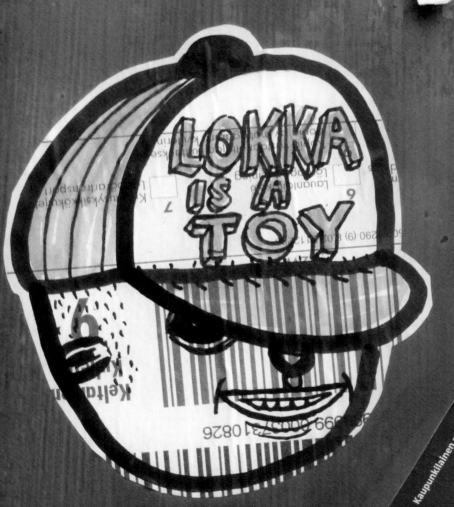

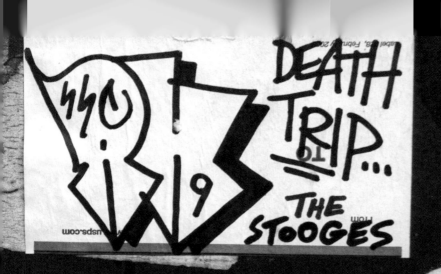

DEATH
TRIP...

THE
STOOGES

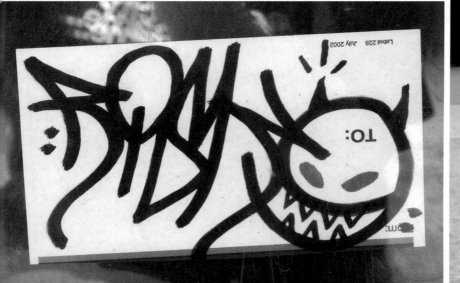

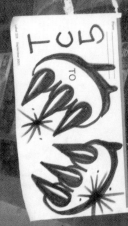

BUSH WILL
BURN US

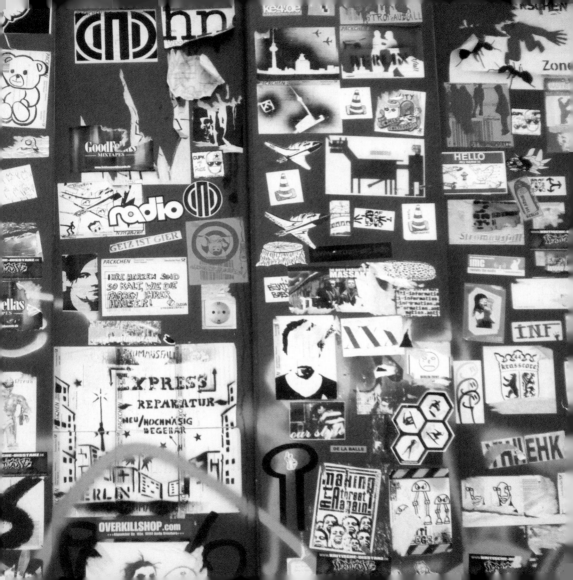

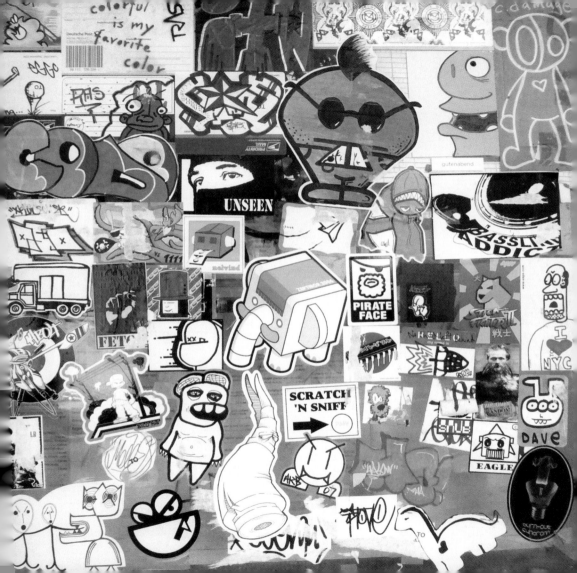

ACKNOWLEDGEMENTS

A big up to all the sticker artists who tirelessly and subversively decorate their cities. Seeing your work always brightens my day. Special thanks to New York's STAIN, FAUST, C.DAMAGE, GET2, COSBE and OVERCONSUME who patiently tutored me in sticker lore and to MALIC & MORG who gave me a tour of the Philly scene. Sincere apologies to the hundreds of artists whose stickers I missed. Lastly, much respect to Buzz, Christopher and Mark Batty for recognizing the aesthetics of postal labels and understanding the value of preserving this ephemeral art form in print.

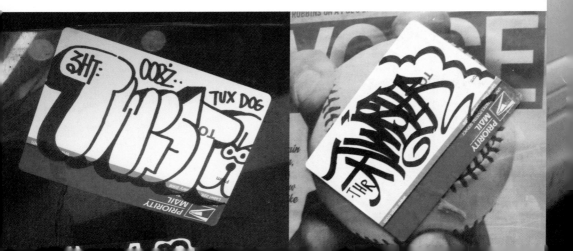

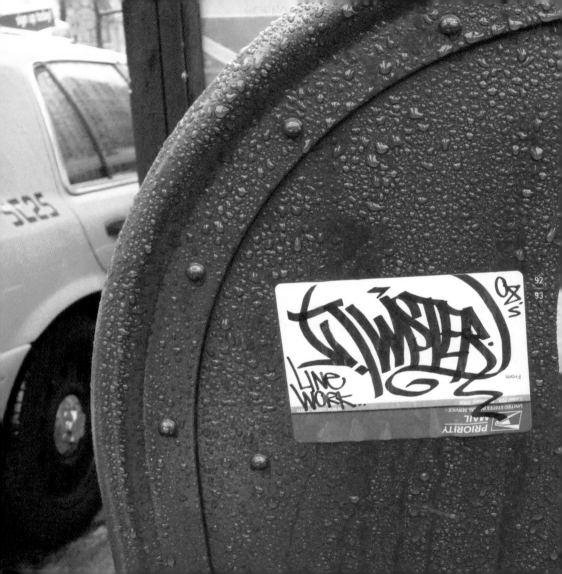

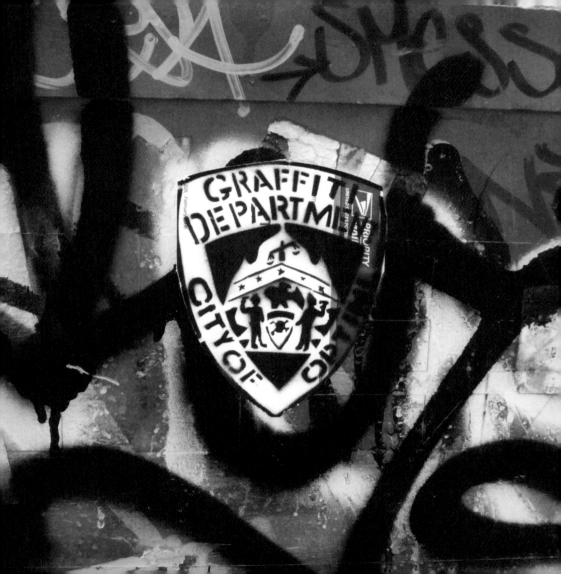

Sticker photos from 2002-2008

Cover (front): TICKY/MALIC, Philly
Cover (back): STAIN, FAUST, COSBE, C.DAMAGE, NYC

GOING POSTAL

All photographs © Martha Cooper

Typefaces used: AUdimat, GAzole, Rotis

Library of Congress Control Number: 2008929886

Printed and bound in China through Asia Pacific Offset

10 9 8 7 6 5 4 3 2 1 First edition

This edition © 2008
Mark Batty Publisher
36 West 37th Street, Suite 409
New York, NY 10018

www.markbattypublisher.com

ISBN: 978-0-9799666-5-1

Distributed outside North America by:

Thames & Hudson Ltd
181A High Holborn
London WC1V 7QX
United Kingdom

Tel: 00 44 20 7845 5000
Fax: 00 44 20 7845 5055

www.thameshudson.co.uk

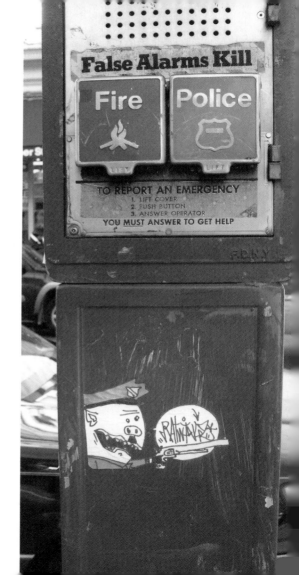

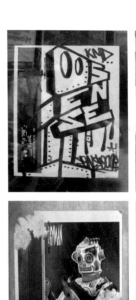
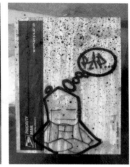
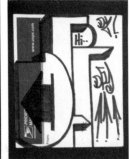
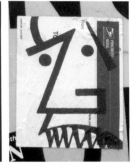
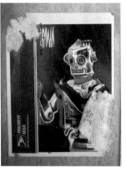
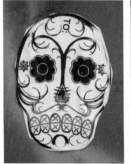
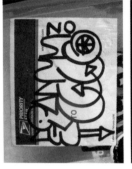
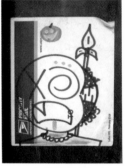
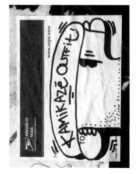
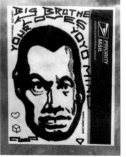
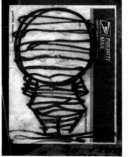
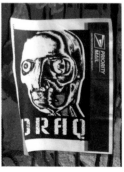

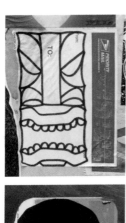
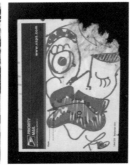
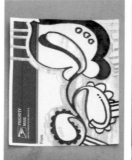
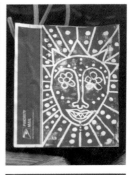
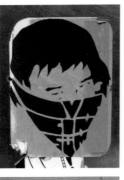
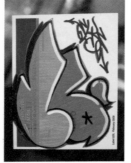
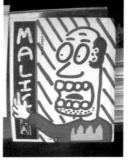
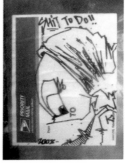
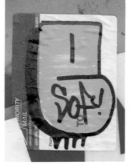
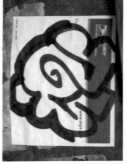

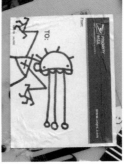